"Only in America"

The Stimulating Life of a Street Artist

Story and illustrations By: Gil McCue

GIL MCCUE

Order this book online at www.trafford.com
or email orders@trafford.com

Most Trafford titles are also available at major online book retailers.

Print information available on the last page.

ISBN: 978-1-4907-6383-5 (sc)
ISBN: 978-1-4907-6384-2 (hc)
ISBN: 978-1-4907-6385-9 (e)

Library of Congress Control Number: 2015949083

Trafford rev. 09/02/2015

 www.trafford.com

North America & international
toll-free: 1 888 232 4444 (USA & Canada)
fax: 812 355 4082

To: Tara, Hope, Susan and Gregg

"For all their support and inspiration"

To Jane, Hope, Susan and Grey,

"For all their support and inspiration."

When I was young and stupid, I made a dumb decision into thinking that one day I would become a rich and famous artist. Little did I realize that in order to become a rich and famous artist, one needs to be uninhibited, self-destructive, and slightly maladjusted.

A famous French artist (who is a legend in the art world) cut off his ear and died before gaining any fame. The only people who became rich were the people that acquired his paintings after his death. Now I ask you, how "self-destructive" is that?

Artists are performers, and like all performers, they need their talent to be recognized. Every musician, actor, photographer, singer or dancer needs recognition. If a performer has exceptional talent it will be recognized and admired. And, if the admirer is willing to pay for that talent, it must be exceptional.

Exceptional talent is a gift and is usually recognized at an early age. I discovered this gift at the early age of eleven when I sold my first drawing to my older brother. The subject was a sketch of his slippers that were casually tossed under his bed in a most interesting composition. I felt compelled to find a pencil and paper in order to make a quick sketch of the scene before the lighting changed in the morning sunlight.

In the late 1930s (the era of the Great Depression), people were wealthy if they owned a dollar bill. After seeing the sketch, my brother reached into his pocket and withdrew twenty cents. That was a lot of money for a kid of my age during that era. I remember both my mother and father's surprised expression to observe the financial transaction take place. As I squeezed the money into my side pocket and gave my brother the drawing, my father remarked, "You're one heck of an artist, but don't try to make a living at it!" Years later in my life I reminded him of that remark.

Like most kids at that age, I loved comic books. Superman, Batman, Captain America, the Torch, Captain Marvel, and several other Super men were born in that era. Although I loved drawing characters from the comic books, my interest drifted toward more humorous comic art.

Walt Disney's "Mickey Mouse and Donald Duck" followed a more story style of cartoon art, whereas "Bugs Bunny and Daffy Duck" were hilarious. I could never get enough of Chuck Jones', "Bugs", "Porky Pig" and "Tweety Bird". Many people do not view cartoons as being real art. Most Successful cartoonists, however, are extremely talented artists and line illustrators. Their art can be forceful, dramatic and energizing. Or, their style can be simple and childlike. Whenever an artist's work is published, their talent is recognized. Long after many cartoonists have gone, their cartoons live on. Who can forget Charlie Schulz and "Snoopy" or Walt Disney and "Mickey-Mouse?"

"The Early Years"

T he grade school I attended awarded a "certificate of excellence" to graduating students for outstanding achievement in every required course. Much to my surprise, I was called on to the stage and awarded "Best in Art" on graduation day. Although both my parents were proud of my award, I was never encouraged to pursue art as a career. By their standards, getting an education, a real job, raising a family and retiring with a gold watch should be the only goal in life. If you lived through the "Great Depression", life as an artist was a road to poverty and a dead end.

World War II changed everything. Both my older brothers served in the Army and when I turned 17, I joined the Navy. When the war was declared officially over, the Navy began to decommission its war-time ships and put them into the "mothball fleet". I was assigned to special services on a

Navy base in Florida which was used to entertain all Naval personal from those ships until they were reassigned to new duty. On that base I met a very talented cartoonist who drew a comic strip for the base newspaper. His quick and clever style in drawing reinvigorated my interest in art. Though the years have passed we remain in touch through our mutual membership in the "National Cartoonist Society". Several top rated publications in this country and abroad continue to buy his cartoons throughout the year. Age is of no consideration in the art world. It's your talent that the world loves and is willing to pay for it.

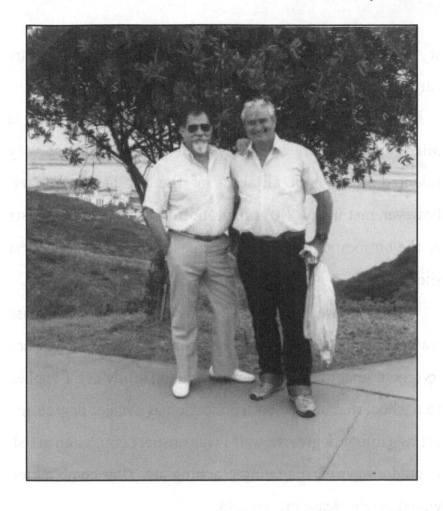

In the field of art entertainment there are several stages of talent. NO talent is at the bottom of the ladder and master artist at the top. Depending on your artistic skill, an artist can range through various steps of the ladder. An artist can excel at watercolor but perform poorly at illustration. Most successful artists find their place on the scale and rarely explore other techniques. Another key to artistic success is

style. As in all forms of entertainment a unique style in art can open the door to success.

In all my years as an artist vender, I never met a Michelangelo. There are many street artists who are very talented throughout all steps of the art ladder. I have, however, met many "NO" talent, bottom rung artists. Artists at the bottom rung usually disappear soon after their first showing.

Soon after we put all those ships to sleep, the Navy base was closed and I was honorably discharged. I chose to go back to school under the GI Bill program and study art. I applied to a school that offered both education as a major degree and art as a minor degree. Now, if I was unsuccessful as an artist, I could always earn a living teaching art. That combination would surely please my parents.

I believe it was sometime during my first year teaching art that I heard of an art gallery in a local mall that was looking to dress their store window for Lincoln's birthday. Since I had recently finished an oil painting of both Lincoln and JFK (who had passed away only months earlier), I applied for the position with both paintings in hand. The owner was impressed enough to display both paintings in his gallery

window for showing the following day. The background was draped with a blue velvet cloth while the lighting was soft on the eye.

Early the following morning I received a phone call from the gallery. "Can you come down here as soon as possible? I have a customer who just bought your JFK painting and wishes to meet with you." When I arrived, both paintings remained on display and there were at least a dozen people starring at them. That moment opened the door for a long awaited desire to fulfill my artistic dreams.

"Getting Started"

After the sale of the JFK painting, I decided to leave the Lincoln painting at the gallery on consignment. The financial split was a 33/66% agreement. Most well established galleries usually expect a higher percentage than 33%. Whatever the agreement is between the artist and the gallery always have it in writing and signed by both parties.

One week later a local art league had arranged to hold a weekend art showing at that very same mall. I contacted the chairperson, showed my art work, paid a small fee, and was assigned an indoor display space for that weekend. I was elated that I could teach school on weekdays and do art shows on weekends.

Indoor art shows provide shade from the sun, protection from bad weather and real rest rooms when nature calls. The most important feature of all art shows is talking directly

with an interested viewer. Also, you're exposed to a larger group of people who enjoy art.

After making several sales that weekend, I was hooked! I met other artists who informed me of shows coming up both near and far. I learned of the contact person, fees or commission charged, rules, parking restrictions, and advised of which shows that were good and of those that were not.

Art shows were new to most towns around the county and the Chamber of Commerce often promoted them. There was music and entertainment as well as an art show in many towns.

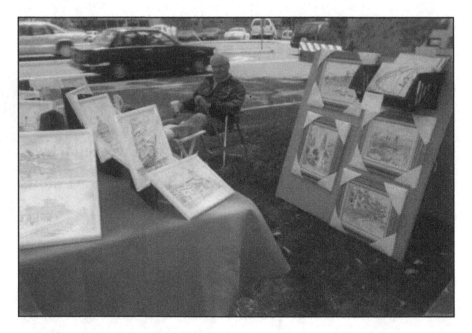

The best of all the outdoor shows that I recall was in Washington Square, Greenwich Village, NYC. It was a juried show which attracted first class artists from most every state in the nation. I remember being assigned a space next to an artist from Detroit named "Joel". Joel painted in a very unique style. I liked his style because it was unconventional, and so was his display. His paintings were never secured and always falling on the sidewalk. They were never framed. If they were scratched or damaged, he would simply take a house paint brush with white paint and touch them up.

Well known celebrities were often seen when that show opened in New York. One such celebrity purchased a painting from Joel. Her name was Liza Minnelli, daughter of Judy Garland of the "Wizard of Oz" film. She suggested that he hold it until later in the day when she would pick it up. As she departed, Joel asked if I had a camera to take his picture with her when she returned. No other exhibiting artist had one to use for the photo. Reluctantly he purchased one at a nearby camera store. Cell phones had yet to be invented.

Liza arrived hours later in a taxi, never got out and had a friend pick up the painting for her. She waved goodbye from the cab window and drove away. The camera store refused to

accept the camera back when he attempted to return it. Their policy was, "all sales are final".

Another celebrity named Peter Falk, (TV star "Lt. Columbo"), stopped to view my display. During our conversation I learned that he loved art and was studying at the "Art Students League" in New York.

When I informed him that I was an art teacher he asked if I would like to critique his work. When he returned with his portfolio, a large and unruly crowd gathered around making it impossible to view his drawings. Although I was able to critique only a few of his sketches, I was extremely impressed with his talent as an illustrator.

When the Greenwich Village art show ended in the fall of the year, I would usually return to those local shows near and around Long Island. Occasionally I would venture to New Jersey, Pennsylvania or Connecticut if I heard of a show that was well attended. One such show was a three day weekend, north of Philadelphia, in a town named, King of Prussia.

The show took place at an indoor mall just two weeks before Christmas. Shows in a mall around the holidays are

unheard of. I couldn't resist making all those potential sales at Christmas time.

I set my display up on Friday, checked into a Holiday Inn, and sat in my assigned space for three days. At noon on Sunday I overheard a boy mention that snow was beginning to fall outside the mall. I quickly disassembled my display, packed my car and headed back to New York. I paid three nights for a room, a high entry fee for the show, sat on my butt for three days and sold nothing.

As I neared Trenton on the New Jersey Turnpike I felt a strange thumping in the rear of the car. It was of course a flat tire! My spare tire and jack were under the stack of heavy framed paintings which had to be removed and leaned on the outside of the car. While jacking the car up during what was now becoming a very heavy snow storm, a red car suddenly pulled off the turnpike and stopped to ask if I were selling my paintings. I couldn't help but chuckle all the way home, having sold two framed paintings, on the side of the New Jersey Turnpike, in a snow storm, while fixing a flat.

"Only In America"

Painting with oil on large canvases requires large heavy frames. The frames can't be cheap frames or the paintings will look cheap. Besides, oil paintings take too long to dry. If you're a street artist, you are required to transport your art to different shows every week. Transporting wet paintings is a disaster. I realized that I had to return to my basic talent of black and white illustration. Pen and ink illustrations have a unique appeal to people who admire detail in the drawings. My pen and ink style of drawing blended well in that medium.

I created a series of illustrations specifically designed with an early American theme. At first I drew old wooden "Yankee Clipper" ships in full sail on a forceful ocean. Since I was now attending more and more art shows in the New England area, I also included old colonial style art which blended well with

the buyer's home furnishings. Black and white illustrations stand out with red mats and oak frames.

Mystic, Connecticut, was a favorite art show of mine that was held once a year. It was the first time that I had ever heard of "blue laws". The law means that it is unlawful to sell any items before 12:00 noon on Sundays. All of the exhibitors would have to wait until the local police sounded the alarm before we could make a sale. There was an old whaling ship called the "Morgan" sitting dockside in the harbor. I was commissioned to illustrate the ship for a local seafood restaurant located in town. When I returned to their annual art show the following year, I dined at that restaurant only to discover that my illustration was being used as a paper placemat on every table.

Another art show that I did well at with this theme was in Virginia Beach, Virginia. I packed my car with only small framed pictures and drove from New York to Virginia. I took the family and made it a vacation. My twin boys enjoyed swimming in the surf, while my wife and I sold every picture we had brought with us. The highlight of that trip, however, was watching the astronauts walk on the moon from the comfort of our hotel beds on that very weekend.

It wasn't often that I would take my twin boys along with me to an art show unless I could keep them busy. They were always bored and rarely helpful. When I did an art show like the one on the boardwalk of Atlantic City, New Jersey, it was fun because we made it a great family vacation. The twins could swim all day if the weather was nice and give me and my wife a chance to talk with potential customers. Traveling long distances to do art shows was expensive and weather dependent. When promoters of outdoor art shows require payment in advance with no refunds if it rains all weekend it becomes very expensive.

I did another art show at a mall in Meredith, Connecticut, that I'll never forget. I vowed to never travel long distances to a show unless it was profitable. It was a first time, weekend show, with no fee and in a newly constructed mall. First time shows can be good because it's usually a novelty to the surrounding community. I was completely unaware that the mall was built in a depressed area.

I hadn't made a sale for two days so I packed up and headed back home. It was snowing on the way home when suddenly my car's engine began to rumble. It would go and stop then go again and stop. Fortunately I had the luck to

come upon a gas station at an exit just off the turnpike. The service man at the station looked under the hood and explained that the problem was a broken bolt which held the carburetor to the engine. He said that he had no bolt like it at the station but he had a few in his basement at home. He then paused momentarily and said, "If you watch the station, I'll go and get one." As he drove away, he shouted out of the truck window, "Take credit cards only...no cash." I was dumbfounded!

He returned to the station within fifteen minutes, bolt in hand and a big smile on his face. "I found one," he grinned. I was still in shock. As he wrenched the bolt into place he told me that he learned how to fix engines when he was in prison. I was now in greater shock after hearing that he learned his skill while in prison and I knew that I couldn't pay the bill. I told him that I had no credit card with me and not enough cash but that I would send him a check as soon as I got home. As I gave him one of my paintings in appreciation for his trust and generosity, he said, "Forget about sending a check. This picture is more than enough."

"Role of Respect"

Artists are a strange collection of personalities. I guess I am one of them as well. It makes little difference to the public in how you dress at a show unless the promoter has a dress code. In reality, the public enjoys an artist's image if it's a little kooky. Artists who show up wearing a suit and tie look extremely weird and out of character.

Artists are entertainers and must always respect the public. There are some artists who step out of that role of respect, and we all get a bad image. Some are very loud, crack bad jokes, smoke weed, and use profanity. Others lie and brag about their art and make themselves very important. And, there are others who sometimes exhibit very bad conduct.

On one such occasion I happened to be exhibiting next to two "gay" male artists who were displaying their paintings on the ground. If at all possible, art work should always be viewed at eye level. Since the public often brings their

families to an art show, artists must always be aware of their children and their pets. Kids like to touch, and dogs like to smell.

One of the gays was short and thin while the other was tall and heavy. Actually, they were amusing in their mannerisms and enjoyable to exhibit next to. Unfortunately, this day was not a fun day. A male dog took a liking to the odder of one of their large paintings on the ground and lifted his leg over it.

The taller heavy gay artist noticed the incident and immediately jumped to his feet, picked up the wet painting, and chased after the owner shouting very loudly. "Madam, Madam, Stop, Stop right now," he commanded. As he showed her the wet painting he screamed, "Your dog just pissed on my painting." With that remark, he grabbed a corner of her skirt and wiped the painting dry. "Now he's pissed on you," he gleamed as he returned to his display. If she wasn't in such a shocked state of embarrassment, she might have called the police. And if she had called the police, I would have been her eyewitness to the event. From that moment on, their conduct and mannerism were no longer amusing to me.

"Changing Direction"

S ometime thereafter, Jaqueline Kennedy proposed that an artist be chosen to design a suitable memorial stamp in honor of her late husband; President, John F. Kennedy. In order to participate in the design, the artist was required to be sponsored by either a Senator or Congressman.

I contacted my County Congressman who was delighted to sponsor me for the event. I painted the portrait in a profile view from a black and white photo I had acquired from a local newspaper. Only three colors (blue, green and white) were combined to give the oil painting a strong, dramatic look. My Congressman hand carried it to Washington, placed it among the other entries and called to wish me luck. There were entries from the finest artists in the nation.

Even though I was not among any of the finalists chosen, it was an honor to be exposed along with so much talent. The paintings not chosen could be left on display for a month and sold at auction if the artist wished to do so. Since there was good interest in all those that remained, my congressman suggested that I leave it for the month and, if not sold, he would pick it up upon his return to Washington.

Unfortunately, the Congressman was injured in a taxi accident and unable to retrieve my entry. His wife informed me that those paintings not sold or returned were put in storage somewhere in Washington. As of this day, I never learned of the whereabouts of that storage space. Perhaps someday my painting will turn up at some local garage sale.

When Jaqueline chose a painting depicting the eternal flame over John's grave in Arlington Cemetery, I realized that I was an amateur among first class oil painters. Oil painting was not my gift to fame. Perhaps promoting art shows would be more lucrative than displaying at them.

With this thought in mind, I made the decision to become rich instead of gaining fame. After all, the promoters of all those art shows I was attending were making money on my talent. First and foremost, I had to give up teaching. Next, I had to contact a significant number of the many talented artists I had met in my travels. Thirdly, I had to find locations that were suitable for successful shows.

I opened an art gallery which was located nearby a high priced, high quality, gallery. Most of the art and sculpture they displayed was primarily for a wealthy cliental. The

customers that came into my gallery appreciated the lower prices and felt that the quality equaled that of my competitor. By owning an art gallery that was opened weekly, I could promote art shows on weekends. All I needed was a part time weekend employee to fill in when I was gone.

As it turned out, the entire adventure was a bad idea. Neither the idea of promoting shows or directing an art gallery was successful. Many of my friends that I had made throughout the years lost confidence in me, and it was obvious that I would never be rich. The few funds I had saved would be depleted within months. But an artist can always make a change in their life because their talent goes with them.

A friend of mine who lived in La Jolla, California, convinced me into moving to San Diego. The weather in Southern California is almost perfect all year long for doing art shows. This move could open doors of new and exciting opportunities in my art world. Without hesitation I purchased a small trailer and packed it with only items necessary to fulfill those long forgotten youthful dreams. Towing a trailer across this great nation is an adventure

all Americans should experience at least once in their lifetime.

The towns and villages located along the west coast of Southern California are ideal for artists. The mountains, the ocean, the sunshine and the cool breezes all blend in harmony for the creative mind.

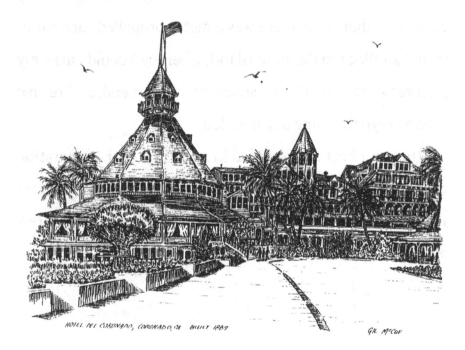

HOTEL DEL CORONADO, CORONADO, CA BUILT 1887 GIL McCUE

Taking advantage of my basic talent of pen and ink illustration, I challenged my skill into drawing several historical buildings, landmarks, and frequently visited tourist locations from San Diego to Los Angeles. There were

art shows already established at Lake Tahoe, Palm Springs, Monterey, Morro Bay, Santa Barbara, and Catalina Island. The only shows outside of the San Diego area that I attended frequently were Palm Springs and Catalina Island.

Catalina Island was fun to display art at primarily because it was a favorite tourist location. However, it was difficult to exhibit art paintings there since the only crossing was by boat. For a short time there was a motor propelled catamaran from San Diego to Catalina Island, whereby I could carry my pictures aboard, do the art show for the weekend, and return to San Diego the same day it ended.

That tour boat cruise ended in its second year of operation due to several failures of its engines. I still have the ribbon I was awarded in 1988 for a black and white illustration I drew of one of their historical landmarks.

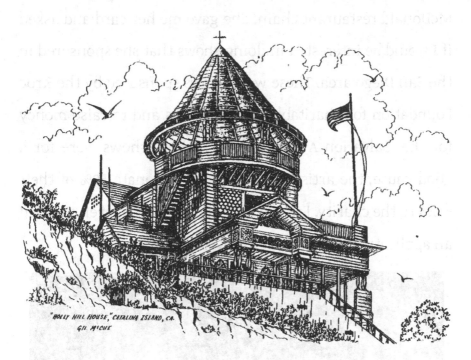

"HOLLY HILL HOUSE," CATALINA ISLAND, CA.
GIL MICUE

Another favorite weekend show of mine was Palm Springs. I liked Palm Springs because it was only a two hour drive from San Diego. The show was held at the "College of the Desert" where your tent had to be set up by 8:00 a.m. This meant I had to arise at 4:00 am, drive two hours, stand in line to pay a fee for a space, and remove my car by 8:00 a.m. It was an interesting show because it was well attended by many Canadian residents who vacationed there for the winter months. The show was also attended by many celebrities and show people from Los Angeles. On one occasion I sold a few color illustrations to Joan Kroc, wife and heir of the

McDonald restaurant chain. She gave me her card and asked if I would be interested in doing shows that she sponsored in the San Diego area. These were shows sponsored by the Kroc Foundation for charitable organizations and to raise money for the, Salvation Army. Although these shows were for a good cause, the artists had to agree to donate 50% of their sales to the charity. I would have agreed, but I never received an application for one of her shows.

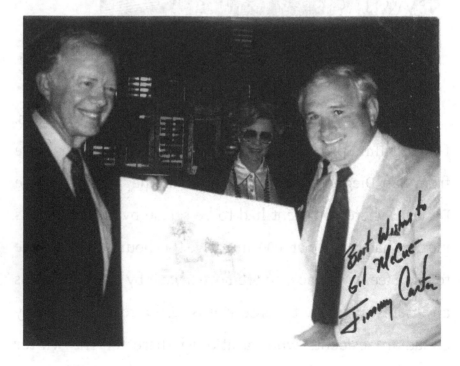

Years later, Joan Kroc recognized my work at a street fair in La Jolla where I was exhibiting that week. She had just lunched with President Jimmy Carter who was visiting San

Diego to acquire financial support for his "Habitat" program. After a short introduction, I gave him one of my illustrations of the famous La Valencia Hotel, in exchange for a photo of all three of us together with my illustration in his hand.

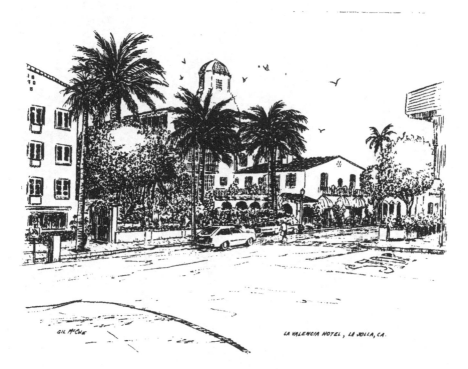

GIL McCUE LA VALENCIA HOTEL, LA JOLLA, CA.

I sent him a copy of the photo which he cordially signed, "Best wishes to Gil McCue" and returned it within a week. I made copies of the photo and sent them to all my family members back east. My mother called to say that my father smiled after viewing the photo and said," I take it all back."

31

"Slowing Down"

D oing art shows two or three times a month was beginning to wear me down. Many of the shows were poorly attended with fewer buyers due to a slowing of the economy. After all, who needs a picture on the wall over a couch or a gift for a friend when it's more important to feed a family? The time had come to make another change in my life.

I attended UCSD the following year in order to achieve a sufficient number of education courses in order to obtain a California teaching credential. I also discovered that I could display and sell my art as a vender at local farmer's markets. Space was limited at these markets so I reduced my display to small illustrations of known scenes throughout Southern California.

Young students in my art classes would often ask me to come to their birthday party and draw caricatures of their

friends. Although I was good at drawing political caricatures, drawing kids lined up at birthday parties wasn't my specialty. Their parents had to agree to my fee in advance before I would accept the invitation. I charged by the head count or sometimes by the hour.

Boys and girls loved it when I would draw their faces. I always made the girls cute and the boys good looking even when they weren't. One girl was so happy with her caricature she had me draw her girlfriend as well. Upon completing the illustration of her girlfriend, I was rewarded with a sharp kick in my leg from under the table. "What was that for?" I shouted as I wrenched in pain. "You made her prettier than me," she glared with an evil eye.

When it comes to beauty, even little girls are hard to please. I discovered early in the art of drawing caricatures, always make the subject good looking if you wished to be paid!

"Copyright Infringement"

It seems that every tourist that travels to New York returns to their home town with a T-Shirt that says "I Love NY" with a heart in place of the word Love. When a word is replaced with a picture or Illustration in place of the word it is called a "Rebus". The idea of creating a rebus design for the city of San Diego stimulated my imagination. This idea became a reality and was soon popular among both tourists and local residents as a T-Shirt or bumper sticker.

On one occasion, as I stopped for a traffic signal, a passenger from a nearby car called out to ask where they could purchase a sticker like the one on my rear bumper. On another occasion, the Public Relations Director of the "San Diego Blood Bank" noticed the design and asked if I would allow the Blood Bank to use my design on their T-Shirts.

© Graphics by: Gil McCUE, San Diego, Ca.

Since the San Diego Blood Bank qualifies as a nonprofit organization I agreed to their request. I was proud to learn that everyone who donated a pint of blood was rewarded with one of my designs. The T-Shirts were so popular in San Diego, both Orange County and Imperial Valley County requested that I design one for their Blood Banks. I agreed to both their requests but ended all future nonprofit designs. Nonprofit organizations don't pay for donations and I never liked the term "Starving Artist".

When an artist agrees to allow any person, organization, or commercial enterprise use of their art work, there must be an agreed upon compensation by both user and artist. In the case of the Blood Bank designs, I had agreed to NO compensation. However, when an artist's work is used without permission, It is called "Copyright Infringement".

Six years ago, I received an unexpected call from one of my sons informing me that he saw a full page ad of one of my illustrations in the telephone book "yellow pages".

The illustration was of the California Tower located in San Diego's Balboa Park. A local dentist was using my illustration to promote his dental practice without my permission. My signature had been erased from the ad and replaced with his dental practice phone number and address.

When I arrived at his office to discuss the matter of copyright Infringement, I was informed that he was not available without an appointment. Upon leaving, I noticed that his business cards and office letter heads were also imprinted with my design. When I returned to my home office, I immediately sent him a bill in the amount of Two Hundred Fifty Dollars ($250.00) for the use of my design in his advertising campaign without my permission.

Within days I received a very nasty letter from his attorney stating that his client had no intention in paying for a design from a print that he had purchased from a local craft store. I decided then that I would take him to Civil Court and sue for Two Thousand Five Hundred Dollars (2,500.00). I felt confident that this was a clear case of copyright infringement. Although the illustration was a print of my original drawing, it still required my permission for any commercial usage.

Unfortunately, the Civil Court Judge didn't view my case as copyright "theft" and dismissed the suit awarding me only my original demand of $250.00 dollars.. When an artist discovers that his artistic talent being used for commercial purposes without granting permission it's worth taking action.

Walt Disney would sue, so why shouldn't you!

"Comic Con San Diego"

E very year in mid-July there is a four-day weekend convention conducted for comic art and held in the city of San Diego, California. The youth (adults too) are particularly attracted to this wild event which has become an annual tradition in San Diego. More and more ticket holders have now become part of the convention by dressing in cartoon art fashion. The convention has unfolded into a midsummer masquerade party. Each year brings forth newer and more bizarre attire. The convention has become a full blown Hollywood scene.

Comic Con was the brainchild of a small group of cartoon artists headed by chairman and president, Shel Dorf. Their first three-day convention was launched on August 1-3, 1970, at the San Diego U.S. Grant Hotel. The convention attracted only 300 people. I attended a later one held at the El Cortez Hotel in 1981 which attracted 5,000 people. Today

there are similar conventions in other cities within the U.S. as well as other countries. San Diego is the largest in the world attracting movie studios, TV networks, cartoon book companies, and 130,000 (2010) attendees and growing.

I knew Shel Dorf's background as a line printer for the dialogue in the comic strips "Dick Tracy" and "Steve Canyon". He was not a cartoonist but was a collector of comic book art. We were both members of the National Cartoonist Society. I recall the year the National Cartoonist Society held their annual meeting in San Francisco, California. A highlight of the meeting was taking a charter bus tour to the "Peanuts" museum in Santa Rosa which is one hour north of San Francisco. It was rumored among artists that Charles Schulz, creator of the comic strip, wanted to name the strip, "Li'l Folks" but the syndicate changed the name to "Peanuts".

"Why do you wish to know if the rumor is true?" inquired the museum director. "I'm a cartoon teacher in San Diego, and my students would like to know," I replied.

"We conduct cartoon classes daily at the museum and we're presently in need of a qualified cartoon teacher. Would you ever consider moving?" he inquired. The offer for a cartoon teaching position was totally unexpected. I hesitated

momentarily, took his card and responded, "I'll think about it." Shel Dorf was present at that meeting saying, "You're a dope if you don't accept the position." The director's card is still somewhere in my desk.

"Last Chance"

On "Kids Day" (the last day of Comic Con) I taught cartoon classes offered to all kids who wished to learn cartooning. My classes were well attended with students from cities throughout the nation...Hawaii included! When Comic Con ended I would teach summer cartoon classes at a program titled "College for Kids" in Oceanside, California.

My background in cartooning opened the door to another challenge. I wrote, illustrated, and self-published two children's books for myself and for other writers. Aside from teaching and illustrating children's books, I managed to create and publish two individual comic strips. The strips were published first in local weekly newspapers with the hopes that one of them would be reviewed and accepted by a national syndicate. I had all the confidence in my world that one of the strips would make the grade. The return mail packages from a half dozen syndicates I had contacted all contained reject slips. My dream was shattered. That was my last opportunity to become rich and famous.

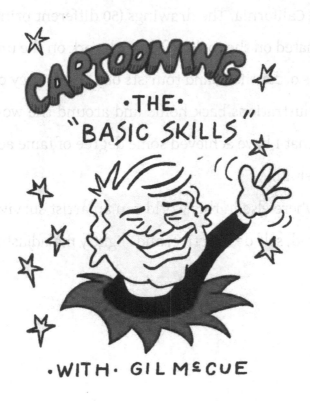

While sitting in my space at the Carlsbad farmers market, I was approached by a first class printer of art subjects. Upon reviewing my ink and watercolor prints, he suggested that my style of art would look good on beverage coasters and magnets. After viewing a few of his samples, I agreed and a new career was born.

The coasters are unique and eye catching. Each coaster is an ink/watercolor illustration of local scenes throughout

Southern California. The drawings (50 different prints in all) are laminated on the top surface with cork on the underside. The stores order them, and tourists buy them. They carry my coaster illustrations back home and around the world. So, I suppose that I have achieved some degree of fame across the globe after all.

And where else in this world can an artist survive who is uninhibited, self-destructive, and slightly maladjusted?

"Only in America"

Printed in the United States
By Bookmasters